BRYONY KIMMINGS:
CREDIBLE LIKEABLE
SUPERSTAR ROLE MODEL

First performed at the Pleasance Dome, Edinburgh, on 25 August 2013.

It transferred to Soho Theatre, London on 8 October 2013.

BRYONY KIMMINGS: CREDIBLE LIKEABLE SUPERSTAR ROLE MODEL

Written by Bryony Kimmings

Performed by Bryony Kimmings and Taylor Houchen

Music and Co-Direction by Tom Parkinson

Lighting Design by Marty Langthorne

Set Design by David Curtis-Ring

Costumes by David Curtis-Ring and Stephanie Turner

Dramaturgical Support from Nina Steiger

Choeography of 'Animal Kingdom' by Figs in Wigs

Produced by Mimi Poskitt

Stage Managed by Hattie Prust and Lottie Vallis

JERWOOD CHARITABLE FOUNDATION ESCALATOR SUPPORTING ARTISTS IN THE EAST OF ENGLAND EAST TO EDINBURGH

LOTTERY FUNDED Supported using public funding by ARTS COUNCIL ENGLAND

Bryony Kimmings is a performance artist based in the East of England. She creates full-length theatre shows, cabaret works, homemade music, sound installations and documentary films. Her work is larger than life, outrageous, visually loud, often dangerous, somewhat unpredictable but above all fun. She is inspired by the taboos and anomalies of British culture and her autobiographical themes promote the airing of her own dirty laundry to oil conversations on seemingly difficult subjects. Her work follows real life social experiments that she embarks upon with genuine genius intrigue and wholehearted, fearless gusto. Bryony's work has been seen in galleries and theatres across the world, most recently at Frieze Art Fair, Soho Theatre, Antifest (Finland), Culturgest (Portugal), Fusebox Festival (Texas), the Southbank Centre, Brighton Festival, Duckie, the Roundhouse, the Barbican, Wales Millennium Centre, Latitude, the Secret Garden Party and Assembly. Her 2010 work *Sex Idiot* won the Total Theatre Award and her 2011 show *7 Day Drunk* was awarded a Arches Brick Award nomination and *Time Out* Critics' Choice award.

TAYLOR HOUCHEN

Taylor attends Westfield Primary School and likes school most of the time. She likes reading and all types of dancing: tap, modern, hip hop and Irish dancing. She also loves Tang Soo Do. She has a big family with three bros and two sisters and when she grows up Taylor wants to be a midwife and is desperate to join army cadets when she's old enough. Taylor likes travelling, but doesn't like the flying part after a bumpy landing made her sick once. This is Taylor's first show.

LOTTIE VALLIS

Lottie Vallis completed her BA Honours Degree in Musical Theatre and Professional Dance at The Urdang Academy, London before training at East 15 Acting School, where she gained a Masters in Acting. She is 1/6 of all-female performance group Fighetta and has performed in various London theatres including Sadler's Wells, Her Majesty's Theatre and the Criterion Theatre. Lottie has strong physical theatre and dance skills and experience in devising her own performance work.

MIMI POSKITT

Mimi is a creative producer and director who works mainly with emerging companies and on concept driven ideas. Credits include: *Theatre Uncut 2013* (Young Vic), Bryony Kimmings' *Credible Likeable Superstar Role Model* (Edinburgh and Tour), *Brave New World 1* (Barbican Pit Lab and The YARD), *School for Scandal* (Park Theatre and Tour), *Chasing the Moon* (RADA). She has worked an assistant producer for ATG and is also the Artistic Director of the award-winning theatre company Look Left Look Right. As well as producing theatre Mimi has also worked for *The Guardian*, ITV and the BBC. In 2007 she won a Royal Television Society award for a documentary about 9/11.

TOM PARKINSON

Over the last thirteen years, Tom Parkinson has developed a practice as an independent composer working primarily in an interdisciplinary context. This has involved music for television, film and radio and over fifty scores for the stage including award-winning theatre and dance productions, much of which has featured live music and performance. His work spans experimental durational

performance, theatre, pop songs and commercial music. Recordings of his music have been played on Classic FM, Resonance FM, Radio 1, 1Xtra and 6 Music. Commercial clients have included McDonald's, Nokia, Channel4 and Sky Sports. In addition to Kimmings, regular collaborators include Keren Levi, Ivgi&Greben and Sharon Smith. He has worked with/ at the Royal Opera House, National Dance Company of Korea, Provincial Dances Theatre Ykaterinburg, Dansgroep Amsterdam, Phoenix Dance Theatre, The National Theatre of Tunisia and Holland Festival.

DAVID CURTIS-RING

David Curtis-Ring is a London-based artist and art director working in music video, fashion, film and performance. In 2008 he graduated from Goldsmiths University with a first degree (Hons) in Fine Art Textiles. Art direction credits include music videos for Arctic Monkeys, Sinead O'Connor, Little Boots and Benny Benassi. Costume commissions include pieces for Arnolfini, Barbican, Sadler's Wells and ongoing collaborations with menswear designer Craig Green and performance artist Bryony

Kimmings. Other credits include set design and props for ArtAngel, Almeida Theatre, Battersea Arts Centre, Converse, Lacoste, Toni&Guy, GQ Style, Hong Kong Tatler and Wonderland magazine.

MARTY LANGTHORNE

Marty is a Lighting Designer working in theatre, live art, dance and music. He has created designs for shows at a range of venues, including the Southbank Centre, Sadler's Wells, the Barbican, Soho Theatre, Belvoir Street Theatre (Sydney), the Roundhouse, Old Vic Tunnels and Wilton's Music Hall, as well as in multiple site specific and gallery contexts. In recent years he has collaborated with Anoushka Shankar, Dickie Beau, Kate Champion, Ron Athey, Annie Sprinkle, Penny Arcade, Scottee, Bryony Kimmings, Duckie, Sheila Ghelani, Chloe Dechery, Curious, Natasha Davis, Bob Karper, The Famous Lauren Barri Holstein, Andrew Poppy, Julia Bardsley, Karen Christopher, Dominic Johnson and Marisa Carnesky.

London's most vibrant venue for new theatre, comedy and cabaret.

Soho Theatre is a major creator of new theatre, comedy and cabaret. Across our three different spaces we curate the finest live performance we can find, develop and nurture. Soho Theatre works with theatre makers and companies in a variety of ways, from full producing of new plays, to co-producing new work, working with associate artists and presenting the best new emerging theatre companies that we can find. We have numerous writers and theatre makers on attachment and under commission, six young writers and comedy groups and we read and see hundreds of shows a year – all in an effort to bring our audience work that amazes, moves and inspires.

'Soho Theatre was buzzing, and there were queues all over the building as audiences waited to go into one or other of the venue's spaces. [The audience] is so young, exuberant and clearly anticipating a good time.'
Guardian

Over 167,000 people saw a show at Soho Theatre in the last 12 months; over 1 million since we opened in 2000.

We presented 41 new theatre shows last year alongside some of the finest comedy and cabaret in the UK.

Our pricing means that tickets are affordable and accessible; our audiences are adventurous and dynamic.

Over 8,000 people attended shows for young people and families last year.

We receive public funding BUT we contribute more to government in tax than we receive.

We create jobs and help develop the UK's talent pool in the creative industries.

sohotheatre.com
Keep up to date:
sohotheatre.com/mailing-list
facebook.com/sohotheatre
twitter.com/sohotheatre
youtube.com/sohotheatre

LOTTERY FUNDED | Supported using public funding by ARTS COUNCIL ENGLAND

We are immensely grateful to our fantastic Soho Theatre Friends and Supporters. Soho Theatre is supported by Arts Council England.

Principal Supporters
Nicholas Allott
Hani Farsi
Jack and Linda Keenan
Amelia and Neil Mendoza
Lady Susie Sainsbury
Carolyn Ward
Jennifer and Roger Wingate
The Soho Circle
Celia Atkin
Giles Fernando
Michael and Jackie Gee
Hedley and Fiona Goldberg
Isobel and Michael Holland
Corporate Supporters
Bates Wells & Braithwaite
Cameron Mackintosh Ltd
Caprice Holdings Ltd
Dusthouse
Financial Express
Fisher Productions Ltd
Fosters
Granta
The Groucho Club
Hall & Partners
John Lewis Oxford Street
Latham & Watkins LLP
Left Bank Pictures
London Film Museum
Nexo
Oberon Books Ltd
Overbury Leisure
Ptarmigan Media
Publicis
Quo Vadis
Seabright Productions Ltd
Soho Estates
Soundcraft
SSE Audio Group
Trusts & Foundations
The Andor Charitable Trust
Backstage Trust
Boris Karloff Charitable
Foundation
Bruce Wake Charitable Trust
The Buzzacott Stuart Defries
Memorial Fund
The Charles Rifkind and
Jonathan Levy Charitable
Settlement
The City of Westminster
Charitable Trust
The Coutts Charitable Trust
The David and Elaine Potter
Foundation
The D'Oyly Carte Charitable
Trust
The Ernest Cook Trust
The Edward Harvist Trust
The 8th Earl of Sandwich
Memorial Trust
Equity Charitable Trust
The Eranda Foundation
Esmée Fairbairn Foundation
The Fenton Arts Trust
The Foundation for Sport and
the Arts
The Foyle Foundation
Harold Hyam Wingate
Foundation
Help A London Child
Hyde Park Place Estate Charity

The Ian Mactaggart Trust
John Ellerman Foundation
John Lewis Oxford Street
Community Matters Scheme
John Lyon's Charity
The John Thaw Foundation
JP Getty Jnr Charitable Trust
The Kobler Trust
The Mackintosh Foundation
The Mohamed S. Farsi
Foundation
The Rose Foundation
Rotary Club of Westminster
East
Sir Siegmund Warburg's
Voluntary Settlement
St Giles-in-the-Fields and
William Shelton Educational
Charity
The St James's Piccadilly
Charity
Teale Charitable Trust
The Theatres Trust
The Thistle Trust
Unity Theatre Charitable Trust
Westminster City Council-West
End Ward Budget
The Wolfson Foundation
Soho Theatre Best Friends
Johan and Paris Christofferson
Dominic Collier
Richard Collins
Miranda Curtis
Cherry and Rob Dickins
Norma Heyman
Beatrice Hollond
Lady Caroline Mactaggart
Christina Minter
Jesper Nielsen and Hannah
Soegaard-Christensen
Rajasana Otiende
Hannah Pierce
Suzanne Pirret
Amy Ricker
Ian Ritchie and Jocelyne van
den Bossche
Ann Stanton
Alex Vogel
Phil and Christina Warner
Garry Watts
Sian and Matthew Westerman
Hilary and Stuart Williams
Soho Theatre Dear Friends
Natalie Bakova
Quentin Bargate
Norman Bragg
Neil and Sarah Brener
Roddy Campbell
Caroline and Colin Church
Jonathan Glanz
Geri Haliwell
Jane Henderson
Anya Hindmarch and James
Seymour
Shappi Khorsandi
Jeremy King
Michael Kunz
James and Margaret Lancaster
Anita and Brook Land
Nick Mason
Annette Lynton Mason
Andrew and Jane McManus

Mr & Mrs Roger Myddelton
Karim Nabih
James Nicola
Phil and Jane Radcliff
Sir Tim Rice
Sue Robertson
Dominic and Ali Wallis
Nigel Wells
Andrea Wong
Matt Woodford
Christopher Yu
Soho Theatre Good Friends
Oladipo Agboluaje
Jed Aukin
Jonathan and Amanda Baines
Mike Baxter
Valerie Blin
Jon Briggs
David Brooks
Rajan Brotia
Indigo Carnie
Chris Carter
Benet Catty
Jeremy Conway
Sharon Eva Degen
David Dolman
Geoffrey and Janet Eagland
Wendy Fisher
Gail & Michael Flesch
Sue Fletcher
Daniel and Joanna Friel
Stephen Garrett, Kudos Films
Alban Gordon
Martin Green
Doug Hawkins
Tom Hawkins
Anthony Hawser
Thomas Hawtin
Nicola Hopkinson
Etan Ilfeld
Jennifer Jacobs
Steve Kavanagh
Pete Kelly
David King
Lynne Kirwin
Lorna Klimt
David and Linda Lakhdhir
James Levison
Charlotte MacLeod
Amanda Mason
Mike Miller
Ryan Miller
Catherine Nendick
Martin Ogden
Alan Pardoe
David Pelham
Andrew Perkins
Fiona and Gary Phillips
Andrew Powell
Geraint Rogers
Barry Serjent
Nigel Silby
Lesley Symons
Dr Sean White
Liz Young

*We would also like to thank
those supporters who wish to
stay anonymous as well as all of
our Soho Theatre Friends.*

Bryony Kimmings

CREDIBLE LIKEABLE
SUPERSTAR ROLE MODEL

OBERON BOOKS
LONDON

WWW.OBERONBOOKS.COM

First published in 2013 by Oberon Books Ltd
521 Caledonian Road, London N7 9RH
Tel: +44 (0) 20 7607 3637 / Fax: +44 (0) 20 7607 3629
e-mail: info@oberonbooks.com
www.oberonbooks.com

A catalogue record for this book is available from the British
Library.

PB ISBN: 978-1-78319-063-8
E ISBN: 978-1-78319-562-6

Cover image by David Curtis-Ring,
Christa Holka and Alexander6

Printed, bound and converted
by CPI Group (UK) Ltd, Croydon, CR0 4YY.

Visit www.oberonbooks.com to read more about all our books
and to buy them. You will also find features, author interviews and
news of any author events, and you can sign up for e-newsletters
so that you're always first to hear about our new releases.

Performance artist Bryony Kimmings is known for her savagely honest and hilarious autobiographical works based on the hair-brained real life social experiments she embarks upon. This year Bryony (creator of Sex Idiot *and 7* Day Drunk*, previous hits of the fringe) returns to the Pleasance with the premiere of her latest show –* Credible Likeable Superstar Role Model.

Inspired by the lack of positive role models on offer for young people in popular media and the increasing evidence of the hyper sexualisation and objectification of Tweens (7-11 year olds), performance artist Bryony Kimmings has teamed up with her nine-year-old niece, Taylor, to embark on an ambitious and bold new project. Part social experiment, part theatre show, part education project with a documentary running alongside it Kimmings has created a non-conventional role model for young people. Her aim is to make this role model famous by manipulating and utilising the current celebrity-producing methods widely used by the Music PR industry. Flipping both the music industry and global tween markets on their head, Kimmings and Taylor are bravely tackling the ethics of the main stream media, David and Goliath style.

Talking about her latest project Kimmings stated 'It just seemed time to give kids a voice in what they consume, they get so much crap thrown at them from every angle!'

Working together over a period of a year, after school and in the holidays, Bryony and Taylor invented Catherine Bennett; a dinosaur-loving, bike-riding, book-reading, tuna-pasta-eating pop star. Since April of this year Kimmings has become Catherine Bennett and Taylor has taken on the role of her manager. Taylor decides what CB does, what she sings about, what she says and what she wears. The idea is a role model pop-star created by a nine year old FOR nine year olds, bypassing the money-making tween machine altogether. Think Fairtrade pop and you're on the right track.

The duo, supported by a team of expert volunteers, ranging from the PR company behind Leona Lewis and Take That to Girls Aloud's make-up team have styled CB, written and recorded three pop songs, launched the pop star's career with

a webpage and Twitter account and their accompanying music videos have already had over 30,000 hits on YouTube. During the early research stages of the project Taylor decided the three songs were to be about friendship, the future and learning to be political from a young age. She also decided (after Bryony made her listen to two days worth of music!) that CB was to sound like 'Lily Allen singing songs produced by the Gorillaz written by the B-52's'. Guided by Taylor, these songs and the character of Catherine Bennett has been designed intentionally to instigate an alternative tween-music scene that doesn't revolve around commodification and sexualisation for profit. The duo have to gain one million hits on YouTube, be on telly and get national radio play to prove that this project has succeeded. So far the pair been invited to meet an MP in the Houses of Parliament, become friends with Yoko Ono and featured on BBC Radio 4 *Woman's Hour.*

The project's aim says Kimmings 'is to explore whether this non-conventional role model character can have the same amount of influence on young people as the current, pop stars we see on offer.' CB has performed at festivals such as Latitude and Southbank Centre's Festival of Neighbourhood and the educational strand of the show has seen CB going into school assemblies to teach kids her weird dance routines and to talk about ethical role models.

Running at the Pleasance Dome for the run of the festival *Credible Likeable Superstar Role Model* is Taylor and Bryony's theatre show, but it is not a show for kids (there is plenty of chances to see CB live available on her website www.catherinebennett.so). Instead it is a show created for adults, performed by Bryony and Taylor. Kimmings hopes that this theatre show can tackle the issues at the centre of their plight in a fun and entertaining way.

'This show is as far away as you can get from a Mary Whitehouse style rant, it asks the hard-hitting questions whilst throwing gorgeous dance routines in your eyes and features us dressed as knights cracking jokes. It's entertaining but, as with all my work, it uses sparkles and cheek to talk about something we find hard to compute. I hope it begs the question what does it really take to be a Credible Likeable Superstar Role Model for a child of the 21st century?'

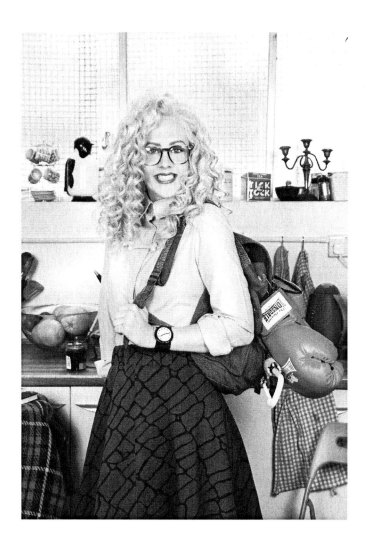

To find out more and follow the Catherine Bennett project:
www.catherinebennett.so

www.facebook.com/socatherinebennett

@RealCB

www.bryonykimmings.com

@bryonykimmings

Future Fauns

Bryony Kimmings thinks of her nine-year-old niece Taylor as a bit like a faun; while for her part Taylor thinks of her thirty-two-year-old aunty as a dinosaur. In a story of a friendship finding projective form, these two shape-shifters are looking to 'put something positive into the forest' and tonight that something positive is *Credible Likeable…*, the theatre element of a massively ambitious multi-platform 'social campaign, theatre show, documentary and educational project' which as a piece of operational realism seeks to beat the global tween machine at its own game by creating a new kind of popstar. In front of a backdrop of a fairytale operatic trees, they go silver like the sixties in futuristic slinky popstar get-up, don armour to ass-kick several buttloads of phantasmic capitalism to thunderous HI-NRG rave ascensions, and in the process produce something unswervably fine, fresh and fierce. *Credible Likeable…* is a hyper-savvy alchemising of Kimmings's self-confessed 'guilt, anger and the buzz of desperation' into a thoughtful, artful, spectacle-relacing shot of pure gold.

As Kimmings admits, her previous work has been criticised for a degree of self-involvement. About *Sex Idiot* I suggested that perhaps 'we can discern some bravery, but the result is a version of feminine sexuality that is obsessed with display, a trapped interiority without insight, caught uncomprehendingly in one-dimensional space.' I'd been reading Nina Power's *One-Dimensional Woman*, and Kimmings' very instinctive, guts out, funny and vigorously self-focused autobiographical work, which would continue in a similar vein with *7 Day Drunk*, seemed to me haunted by the pathologies that Power was pin-pointing in late-capitalist versions of women's emancipation. Chiefly that in the sassy celebrations of chocolate, pole dancing, shopping: 'the political and historical dimensions of feminism are subsumed under the imperative to feel better about oneself, to become a more robust individual.'

It was in that light I read Kimmings' art not as a problematisation of chocolate so much as a ragged hour-long search for the pole. The 'post-feminist' binary underpinning a route of liberation through daring acts of sexual display remained unquestioned, and so what Kimmings won over gender through balls-out feminine immoderation and excess felt undone by the egoic

emptiness of spectacle. The apparent inability for Kimmings to connect her struggle to something beyond herself as defined by her compulsions was difficult to watch. Her quests to manage and govern herself through institutions and terms (specifically the scientised self-management rhetoric of *7 Day Drunk*) that may be been more accurately described as coterminous with the problem, prompted a sinking feeling. And while Kimmings was not short of intelligent admirers, for me the questions were blurry and the answers were sharply circumscribed by dominant logics. These read like symptomology. The kind of tragedy from which you want to look away as it's just too much.

With *DIY Christmas* Kimmings took a swerve, the abundant pop sensibility was stripped down to that of the indie-maker, if not the narrowband – a nativity that could be 'for everybody', it went head-on against the annual feast of consumption. 'Children think of Christmas as presents and chocolate and Coca-Cola and TV – probably – and I'm not 100% convinced that's what it should be about', she told the magazine I edit last year, adding 'it's really weird because I totally hate people who work with kids'. Interesting to contrast this attitude with Peaches, (with whom *Credible Likeable…* shared a platform at Yoko Ono's Meltdown this year), who was a teacher before she sought to 'infiltrate pop music', getting her kids to sing songs about animals and marvelling at their imaginations and their 'ability to realise anything'. But where Peaches pop career has been critical in the sense she came at a point where it was possible to twist dominant masculinist sexualities against themselves and produced shock and controversy at this untamed, excessive woman simply mirroring normalised gender roles, a strategy that perhaps has its limits (it's arguable to where an interview in *Hustler* and soundtracking the Jackass movie moves us to, if it moves us anywhere) and one Kimmings freighted with runaway irony in *Sex Idiot* just as she chased it down - *Credible Likeable…* on the other hand seems to belong to a different moment.

If one suspects Kimmings has previously harboured ambitions of becoming spectacle – the brash logo, the lush hyperreal photos, the hunger to be loved and that superstar ego – here, by putting something positive in the forest, termed as pop but not on pop's terms, something uncompromising, optimistic and suigeneris, which might be doomed to fail but won't countenance pre-empting that with irony, it feels like Kimmings has produced one of the most crucial works yet for a gathering critical moment. One

in which we are less inclined to rub and read furiously against the grain in the time-honoured critical fashion, but dropping the dead wood and beginning on a new tree, seek to establish the forest in all its diversity. This question of heterogeneity is in the air tonight, and even as the pop songs and dances become ambiguous living critical texts in their own right, they seem to embody their construction. In *Apathy*, the pick of the project's catchy pop songs, this threshold moment gets addressed as a question of action to buzz through young minds: 'is it critical of me / to try to disrupt the flow?'

And so dictated by nine-year-old Taylor who will become the Svengali manager, an unlikely popstar is born. Catherine Bennett works in a museum with dinosaur bones, she's twenty-nine, likes tuna pasta, goes to the gym every day to practice her martial arts, has a proofreader boyfriend called Matthew and a Bassett Hound called Chelsea. She likes dressing up as animals, octopuses 'and, of course, Victorian boys'. She is to sing songs about animals, funny-shaped vegetables, and the future. She is an ordinary lady. The idea is that she becomes famous, where fame means: one million hits on Youtube, magazine and newspaper coverage, television appearances including being flown to LA by the Ellen DeGeneres show, a national radio play (for some reason) and an offer from a corporation to buy her out so the two can turn it down. It might be a slight spoiler alert, but Catherine hasn't quite achieved this yet. She appears on stage singing her slightly dodgy song about the future to cracked xylophones, bereft of popstrel lungs, picking at her sparkly dress and letting the threads float down defeatedly.

You'd suspect money would be the main issue here. At a time when even spontaneous-appearing viral hits frequently need the concerted efforts of multiple interested digital actors, the Arts Council can surely only pay for so many viral consultants, clickfarms and astroturfers (so many, in this case, probably being none at all). And so Kimmings focuses on the grassroots and the 3.0. A tour of schools and this theatre show in which the project can be thrown back upon the reasons for creating it. And what we see as the show's imperatives are heroic. Kimmings' determination not to be a liberal artist, not Nietzsche's saint lost in the woods, not fake, here lend rigour and power. We get autobiographical direct address which is unflinching, anger and rage at the wrongness of the world, a self-coruscating and determined honesty. Most of all we see this born from a place

of genuine connection – a really deep care for Taylor and a relationship through which she has grown to face the world in a different way. As much as Taylor is directed by Kimmings it is the other way round; as much as Taylor is growing up with Kimmings, it is reciprocated. In the forest she whispers to the faun protectively 'you can climb under my belly', and the final dance number in which Kimmings goes gently, restrictedly through the motions, allowing Taylor the spot, is a heartbreakingly powerful closure on a kind of youth.

Taylor is a star no doubt, and if a sense of women enjoying themselves on their own BFF terms and a mutual display of support has been a keystone to girl groups from The Supremes to Atomic Kitten, then these two shine as co-conspirators, even as they don headphones in turn to give the other some private gabbing time, gently slagging one another off (a canny move that dispenses with any kind of familial homily; how to present a unitedness that is non-normative). In a funny set-piece Kimmings responds to the world by gouging out her niece's eyes with a spoon, gorily pulling out glitter-tendoned eyeballs, precipitating Taylor to come front stage with a bloodied bandage over her eyes to whisper terrifyingly to us about networks, that she is the oracle at the frontiers of information, 'you know so little about power' she repeats over and over like a cyber-Cassandra.

Later, shifting register, Taylor tells us about her day, in that elliptical breathless Cresta Run of 'and thens' typical of a nine year old, becoming quite enthused when talking about the time they wanted a new word for 'snuggling' ('Bubbling' is Taylor's suggestion, but 'folding' it seems was 'the best because that's what we call it now.') This establishing of nine-year-oldness is completed with such wit, care and downright respect for Taylor it shines as the testament to their friendship, their difference, an aunty's love, and the superbly collaborative tenor of the piece. At the same time Kimmings establishes their difference in more alarming ways. 'Show me the Katy Perry dance you learned' and Taylor enthusiastically mimes some sexy poses, concentrating hard on the moves and how her body appears, with that slight robotic gaucheness of the child. Behind her Kimmings strips to her bra and begins writhing, slipping hands over legs and breasts, in a note-perfect rendition of the kind of thing that wouldn't garner a single Ofcom complaint on prime time, but here is powerful white-dot shock-treatment. At one moment, while Kimmings de-kits Taylor has to go round the back for a

costume change as 'the theatre didn't think it was appropriate', prompting sardonic laughs from the audience. A reminder that the effects of the sexual exploitation of the child's image are, literally, everywhere. It's a tightrope Kimmings plays with grace and sober style, no wobbles because she started from a sprint, precise as the stellar-tight dance routines which at the untroubled peaks gives us the joy of pop uncomplicated and dreamy.

There is bliss, and transcendence through pop, just as there is the ideology that Catherine Bennett is struggling ferociously with. And connected to these is the fact that pop music is the privileged site of libido in society, where desire is formed and produced, and we are confused little desiring machines at nine, as we act out and learn sexuality through pop. *Credible Likeable...* finds a graceful way to acknowledge this: through the operatic sense, the finely styled choreography, the backdrop and costumes, the metaphor of the forest – threading in the high art codes which undercut the fun with seriousness. Seriousness as the opposite of high-minded. Like the faun and the dinosaur, we can be adult about this.

Debussy's *Afternoon of the Faun* caused a conjuncture in music; it's to where Pierre Boulez dates the birth of the modern era. And Nijinksy's 1912 ballet was shocking too for the apparent appearance of a faun masturbating onstage. It's enough to leave that reference there. In a culture where we see too much, Kimmings' art is intelligent, protective and honest to the last.

Daniel B. Yates. Edinburgh, 2013.

Credible Likeable Superstar Role Model was first performed at the Pleasance Dome, Edinburgh, on 25 August 2013. It transferred to the Soho Theatre, London on 8 October 2013.

Performed by Bryony Kimmings and Taylor Houchen

Music and Co-Direction by Tom Parkinson

Lighting Design by Marty Langthorne

Set Design by David Curtis-Ring

Costumes by David Curtis-Ring and Stephanie Turner

Dramaturgical Support from Nina Steiger

Choeography of 'Animal Kingdom' by Figs in Wigs

Produced by Mimi Poskitt

Stage Managed by Hattie Prust and Lottie Vallis

A fairytale glen in a forest kingdom.

A mound of simulated earth with moss grass and flowers covers the back of the stage. Behind this mound is a backdrop with a forest (or a version of a forest from a dream or a book) painted on it. Sparkling and ethereal. The mound and the backdrop make a little playing space, an island in the black theatre.

DSL and DSR set away from the clearing there are two microphone stands – one adult-sized and one child-sized. Rushes and flowers grow around the mic stands to create little islands in pools of light.

Props:

On the island is a large military rucksack, an iPad, silver ear defenders for a child, a real red apple, a sparkly fake red apple, a green plastic cup, a speech on cue cards and a fake large cupcake, sparkly with stupid red cherries on the top. In the rucksack is a child-sized light green medieval princess dress, extraordinarily long in length, a silver dish with two fake eye balls with twelve inch long sparkling fake tendons attached, a silver spoon and a bloodied child-sized blindfold. Two silver baseball bats stick out the top.

Behind the mound and backdrop is a silver catering table on castors. 155cm in width and the exact length of the child performer. Additionally there are two medieval knights' costumes (chest plates, boots, gloves and chain mail), another adult-size medieval princess dress (extraordinarily long in length in navy) and a Catherine Bennett costume (dress, trainers, wig, make-up, glasses and dinosaur bone necklace).

Performers:

Bryony – The aunty, a thirty-two-year-old woman.

Taylor – The niece, a nine-year-old girl.

Catherine Bennett – a fictional character played by Bryony.

Pre-show – as audience enters.

Bryony and Taylor are wearing matching Victorian schoolboy outfits. Puffy pantaloons shorts with matching buttoned up shirts both in flock printed blues. White Socks and little brown shoes. Each outfit has an antique white lace collar with a large bow attached at the front. They look stuffy and formal, done up tight. They have matching hair, long, dark blonde and straight, done up in a half pony tail. They look like family, like two versions of the same person, one adult, one child.

Bryony sits in the middle of the mound; she is reading an old red book. Bryony is holding onto a leather lead attached to a harness around Taylor's body. It is dull blue, leather, slight S&M. Taylor is moving in a semi circle around the black spaces of the stage between the mound and the mics, around the perimeter of the mound. She is practicing her Irish dancing, over and over and over – a little routine. Every now and then Bryony looks up to check on her or quietly comment or instruct. Taylor is content.

There is music under this action. A harpsichord refrain repeating over and over again over the sound of a droning <u>and</u> the sound of rain. It is quietly foreboding.

NOTE: Both performers play themselves throughout this piece. Apart from when Bryony becomes Catherine Bennett, there is no acting.

S1

The music fades, BRYONY (B) pulls TAYLOR (T) into the mound on her little lead, releases her from it and both performers ready themselves in front of the mound. They stand still, both hands clasped at the left hip. They regally scan the vista ahead, majestic. Jessie J's 'Domino' begins to play. As the first verse kicks in the pair immediately change, suddenly smiling, suddenly animated. The pair play out a simple dance routine they have made up. They laugh, they sometimes sing the words, they enjoy it.

'I'm feeling sexy and free…'

Hands run down the front on the body.
Pump arms up outstretched and clap, twinkle fingers down the front of the body.
Point to the audience and ball change to the right.
Crouch down and explode into the air.
Walk forward two paces drop to your bottom and splay legs out wide in the air.
Running backwards pumping arms.
Wagging fingers at audience both hands arms outstretched twirling fingers round the head while doing the pony.
Shake body and roll thumbs alternately to chest.
Shrug shoulders twice while facing each other.
Alternate hands to the sides and pump chest twice.
Beckon the audience in.
Snake right finger into the air to the top.
Play the drums right and play them left.
Right arm the left arm extend out to the sides and chest pump.
Beckon the audience in.
Snake right finger into the air to the top.
Step toward ones another and raise arms at the sides sharply whilst screaming

Circle out from one another opening arms in a full circle.
Shimmy and pump shoulders right then left.
Stretch up into the air to the right of the body and drop
arms to the floor quickly.
Rotate around each other pretending arms are a clock.
Run at each other hold hands and do a roll under your
own arms.
Freestyle and head towards mics.

Music fades to an instrumental version and plays under the
next scene.

S2

BRYONY at her mic. TAYLOR at her mic.

B: Hi. I'm Bryony. This is Taylor. She is nine years old. She likes Tuna Pasta, Martial Arts and Jessie J. She is my niece. My sister is her mum.

I have always thought of Taylor as the fawn. You know, the tiny deer? This is because… *(Turning to TAYLOR.)* Tay, close your ears. This is because she is sweet and innocent, a little bit clumsy, and annoyingly inquisitive.

She is in my care for the whole summer *(Pulls worried face.)* I am trying to keep an eye on her as best I can with the lead and that. *(Gestures to the harness on her.)* Now I knew I wanted to make a show about children of the 21st century. But I also really wanted this summer to be magical time for her… Hence all of this *(Gestures to the mound.)*

Some people say we look alike. I cannot see the resemblance.

Gestures to TAYLOR to remove her fingers from her ears and makes an unplugging sound with her mouth.

T: Hi I'm Taylor, this is my aunty Bryony. She is thirty-two years old. She likes walking, smoking, being quiet and

sushi. I think of her as the dinosaur, she is the dinosaur. This is because…

Pause.

Aunty Bry

B: Yes?

T: Block your ears please.

(BRYONY does so slightly begrudgingly, rolling her eyes.)

This is because she is old, bigger than me and has something wrong with her back.

She is fun, a little bit weird and sometimes seems angry.

She has shows called *Sex Idiot* and *7 Day Drunk* and she thinks that I don't know that.

I am looking forward to spending the summer together. As we will get to know each other more.

Gestures back to BRYONY to remove her fingers from her ears.

B: About a year ago I moved much closer to Taylor's hometown. I found I was hanging out with her a lot more. Picking her up from school, going round her house, watching TV. I came into much closer contact with the media she consumed and in turn the role models that popular culture seemed to be offering her. TV and the internet seemed to make a lot of her little world go round. I quickly decided that I wanted to find her some better role models to look up to. This is the story of a journey of discovery. Taylor.

T: Yeah

B: Shall we start at the beginning.

T: Yeah.

B: Good.

This is 'What the World Expects from Us.'

S3

BRYONY and TAYLOR run like kids to the mound. BRYONY picks up the oversized cupcake and they play out a little simple scene.

BRYONY offer the cupcake to TAYLOR, right in front of her face, other arm outstretched in an over-the-top stance.

BRYONY looks out to the audience, face completely elated.

TAYLOR pushing the cupcake away firmly, lips tightening.

TAYLOR turns her face to the audience angry at the cupcake. BRYONY bows her head in shame.

B: And this…

TAYLOR and BRYONY jump simultaneously off the mound.

Pause.

The pair affect a swagger, South London-style. They scope each other out, rotating around one another as they travel upstage. Their voices are all mean and cutting. They are in competition.

T&B: Mmmmmmmmmmmm.

T: What's she looking at?

B: Mmmmmmmm what's she wearing.

T: Same as you!

BRYONY fake surprised by the cuss, wags her head from the neck and kisses her teeth. The pair drop back to neutral.

B: And this…

BRYONY drops down to TAYLOR's level. She finds a handsome man in the audience and points at him. She affects the voice of a 'girl'.

B: Oh Taylor, look at him. He's handsome isn't he.

T: Yeah

B: Do you fancy him.

T: *(Excitedly.)* Yeah!

B: Me too!

They fan their faces as they look at him, 19th century hysteria, shy and silly. They take deep breaths, hyperventilate and faint in unison.

B: Oh and of course, it expects this...

The pair run back to the mound. BRYONY makes the pose of Snow White or perhaps Sleeping Beauty in the forest. Her hands at one side of her face in a fake frame. She helps TAYLOR to do the same. Music plays. It is the music of fairy tale moments when a princess is in a forest talking to animals. BRYONY shows TAYLOR how to pull the right vacant face.

BRYONY calls for a bird in an operatic fairytale way into the imaginary forest kingdom before her.

BRYONY watches the bird swoop and fly towards her, TAYLOR watches it land on BRYONY's finger. They both pet the bird, very happy. BRYONY transfers the bird to her other finger and it whispers in her ear.

B: *(In a princess voice, high and stupid.)* What's that?

Looks down at her outfit and bows her head, for the compliment she has received is so gracious and noble.

Why thank you!

Bub-bye

She releases the bird off into the air and waves after it, both of the princesses settling back into the poses on the mound.

B: But what Taylor really wants to know about the world is this...

BRYONY pats TAYLOR on the bum and TAYLOR runs to her mic.

S4

Counting out the questions on her fingers TAYLOR speaks clearly and concisely in her own voice, not acting. BRYONY watches from the mound eating a red apple and laughing at the things that make her laugh that day about TAYLOR's questions.

T: What does credible mean?

Can girls be in the army?

What is it like going to grown up parties and do the dinosaurs get drunk?

What does feminist mean?

Why aren't we wearing the princess dresses that you said we would?

What exactly is wrong with wanting to have more money than the Queen?

Did Yoko Ono really split up The Beatles?

What if I start calling you mum by mistake?

If Chris Brown hits Rihanna, why is she still her girlfriend?

B: What!?

T: Why do you always have a different boyfriend? *(BRYONY takes this question like a punch to the heart.)*

Mum says you are selfish, is that true? *(BRYONY takes this questions like a punch to the face.)*

Why does Katy Perry sing about girls kissing each other like it's a naughty thing?

B: *(Struggling with the punch pain.)* I don't know Taylor!

T: Why don't you have any children? *(BRYONY takes this as a direct hit straight into her solar plexus jumping a little at its force.)*

B: Right in the womb!

She struggles towards TAYLOR and puts her hand over her mouth and holds her firmly at her side, ducking down to TAYLOR's mic.

B: That's enough questions for now Taylor.

I asked my sister if I could make a piece of art with her about role models. She said 'yeah' but said that I had to take care of her. She called her 'Precious Cargo'.

S5

Shouting in a fake fun ironic way.

B: Hope on board the Aunty train! Toot Toot! LOL!

TAYLOR spins round quickly and excitedly, she likes this bit. Hopping onto BRYONY's feet in a dad dance pose, arms clasped around BRYONY's waist. BRYONY moves TAYLOR across the front of the stage lifting both hers and TAYLOR's feet as she shuffles and dances her. She makes the sound of a train. Hops her off and sets her down centre stage.

B: Well you look hungry little one.

Would you like some of my delicious apple?

T: Yes.

BRYONY takes a bite of the apple and rolls the rest offstage. She chews and swallows it. She takes hold of TAYLOR's face. TAYLOR opens and closes her mouth. BRYONY begins to regurgitate the apple. Gagging and forcing it back up like a bird feeding a chick. She manages to get it into her mouth and feeds it to TAYLOR.

Pause.

They both turn their heads to the audience.

B: What?!

I'm looking after her!

(To TAYLOR.) Taylor, go and put on your ear defenders and play on your iPad.

TAYLOR runs to the mound, lays on her front with her ear defenders on and plays Temple Run – Return to Oz on the iPad. The sound of the game is ever so slightly hanging in the space. BRYONY heads to her mic DSR.

S6

B: This is 'What Can I Offer Her?'

She looks over her shoulder in a scared way, like she is scared by the child.

I live in a shitty flat in East London. It's full of damp, mice and sequins.

I voted the wrong way at the last election. You can blame me for not sticking to my Labour guns.

I am unlucky in love, a loud mouth and a bit bitey.

I waste food. Do you do that?

I go and buy a load of food from the supermarket at the beginning of the week, I get it home and look at it, like a proud healthy citizen of the world. Then I go out every night of the week 'til very late and on a Sunday I open my fridge. Look at the food all moldy, and then I throw it in the bin.

I eat McDonald's three times a week. I drink Starbucks. I am the person that will buy the next Katy Perry album first.

I don't give money to charity.

I fund the drugs trade.

I used to watch a lot of porn, I've given it up recently. I was worried it was taking over my life.

I have made mistakes. I worry my mistakes will have ramifications.

(Pause.)

I worry that I am dumb as fuck.

I worry that you think I'm fake.

I worry that I am self-obsessed.

I worry that if I don't put my make-up on you will think I am ugly.

I worry that I'm barren.

I worry that I make work about first world problems.

I worry. When I see her looking at me in the car, emulating, absorbing, learning.

So I asked me sister, 'what can I offer that?' *(Gestures again to TAYLOR in the same way.)*

And my sister said *(Adopting a righteous voice.)* 'Bry. You can teach her how to fight the fight.' *(Holds her fist up, Black Panther style and pumps it a little on the words.)*

And I said 'teach her how to fight?'

Pause.

(Excitedly. Like she has discovered a secret.) OK!

S7

BRYONY runs quickly to TAYLOR, throws down the iPad, rips off the ear defenders and stands her up. Raises her dukes and punches her square in the face. There is a sound effect of a very fake punch. TAYLOR lets out a squawk. She walks forward holding her nose. BRYONY watches her intently. TAYLOR checks her nose for breaks and then blood. Her eyes watering and angry.

B: Come on Taylor, toughen up babe.

BRYONY grabs the two baseball bats from the rucksack on stage. Music begins. A thumping track of training montage quality, complete with sound effects.

BRYONY bangs the bats together and TAYLOR jumps backwards into position in front of the mound. The pair play out the classic action/sports film training montage moments in complete unison, like a dance. Some moves are classics, others stick out like disco moves.

They pull the bats out like they are swords sheathed on their backs and roar.

They bash the bats into their hands threateningly.

They put the bats between their legs and fly them like broomsticks.

TAYLOR throws her bat and BRYONY catches it.

They bow at one another like sumo wrestlers.

They tie on their boxing gloves, staring each other down.

They touch gloves.

They air punch. They shuffle ball change, they stand like karate cranes.

They mummy walk forward. They star jump back.

BRYONY speaks to TAYLOR like a trainer, pumping her and sending her into battle.

TAYLOR screams at the audience to bring it on. BRYONY has her back.

TAYLOR runs and jumps into BRYONY's arms. BRYONY holds her limp body.

BRYONY looks to the heavens and drops to her knees in disbelief.

BRYONY rolls TAYLOR across the stage.

They pretend to be monkeys yelling and travelling to the mound.

They do Tang So Do poses in succession, punches and kicks.

They pretend to be boxing ring beauties.

They hit punch bags.

BRYONY is on her knees in a daze TAYLOR is telling her to keep going

They run up steps like rocky.

They celebrate arrival at the top.

They thank the crowd graciously.

They cross their chests and kiss their necklaces for luck.

They carry heavy tree trunks.

They play the drums.

It breaks back to reality and the music fades away. BRYONY punches at TAYLOR and she blocks. She then runs and gets the cup, her ear defenders and BRYONY's mic. In a dad's voice...

B: Good boy! Well done son. Yeah tough guys ain't ya. Ohhh yeah good punch, block block, we will make a man of your yet son. Go on son, good lad.

TAYLOR places the mic in BRYONY's hand and sits at her feet. She begins to play the game 'Cups', tapping out an endless pattern on the floor with her hands and the cup.

B: *(In a girl's voice.)* Thanks.

S8

She watches TAYLOR for a moment exacerbated.

I began to research into the world of nine-year-old girls. I wanted to get into their heads. This for example ladies and gentlemen is 'Cups'...it was the biggest thing in Taylor's school this term. It was huge across playgrounds across the UK.

It is essentially tapping.

(She watches shaking her head and laughing. She speaks factually, not in a judgmental way.)

At nine in big brand marketing speak you are considered a tween. Literally In-Between child and teenager, aged 7-12 years and female.

At nine, as a tween, you have your very own marketing technique. It's called pester power. This is essentially adverts to induce skirt pulling and temper tantrums, clear and easy ways to pit the child against the purse string-holding adult of the family.

At nine, as a tween your top-selling products for 2012 were Bratz thongs, peelable nail varnish, the music and merchandise of the Pussy Cat Dolls and Stardoll, an online avatar game where you can teach your doll how to cook, clean and care.

At nine you are seven times more likely to develop an eating disorder and four times more likely to develop a narcissistic personality disorder than kids were ten years ago.

At nine, psychologically you are in the latency period, a very self-obsessed time of your life. You run in packs, your copy one another and you wish you were older.

She kicks away the cup in a bit of an end of tether moment. And quickly smiles at the audience. TAYLOR sulks.

I don't remember being nine. I can remember snapshot moments, but not what it was like in here *(She taps her head.)* or here *(She taps her heart.)*

So ladies and gentlemen…

She pulls TAYLOR up and takes off her ear defenders and hands her the mic.

This is 9

S9

TAYLOR heads centre stage with her mic, BRYONY goes into the audience to relax and watch.

TAYLOR has selected four stories that she wishes to tell before the show begins. These stories are anything she wants about her life or her family or her worries about life. The only rule is that they can't be about Catherine Bennett. They usually seems to revolve around her little sister Martha, things she has bought and things that happen at school. She speaks clearly and from her own brain and voice. The effect, as an adult looking on is more mesmerizing and not in TAYLOR's control. The audience observe how her body moves nervously, twiddling her clothes or turning in her toe. Her voice and its awkward inflections, her struggle when what she says doesn't land how she wants it to. It's like watching a nine year old. Plain and simple. It lasts longer than it should. BRYONY decides when to interrupt.

B: Oy Taylor!

T: Yeah

B: I said show them what it's like to be nine, not 'show them how boring nine year olds are!'

Pause.

T: OK.

Pause.

Can I show them the Katy Perry dance I learnt instead?

B: Yeah OK, go on then, I love Katy Perry.

BRYONY heads back onstage and stands to the SR of the mound watching.

TAYLOR strikes a pose centre stage, hand flung into the air the other on her cocked hip. She shouts to the technician.

T: Play my song!

Now.

BRYONY looks shocked but lets it pass. She watches TAYLOR, neutral faced.

Katy Perry's 'Teenage Dream' begins to play. TAYLOR dances and gesticulates a routine she made up but with moves she has no doubt taken from popular culture, harmless but pouting and provocative in its own infantile way. She lip-synches the words out to the audience, pointing and gesturing along with the lyrics, back and forth across the stage. Looking people in the eye. Tilting her head downwards and looking up and outwards, in a mock shy way taught to her by her Aunty Bry.

'You think I'm pretty without any make-up on…'

All of a sudden BRYONY joins in. She simulates the moves of a popstar mixed with a stripper, she removes her shoes, socks, tops and shorts to reveal a bra and a pair of silver shiny leggings. She grinds and poses and touches herself. An adult version of TAYLOR, set back so the child cannot see.

TAYLOR stops DSC and BRYONY gets on the mound. They do this last bit in unison. Running their hands down the front of their body, tapping their pockets and beckoning the audience in. TAYLOR makes her way backwards to the mound where the pair stand together.

The music stops.

TAYLOR looks expectantly at BRYONY, waiting to know what to do. BRYONY looks at TAYLOR, then the audience, then places her arms across her chest to cover her breasts.

B: Go and get changed, now.

TAYLOR takes her ear defenders and baseball bat offstage and behind the mound and she changes into her medieval knight's costume. She drinks some water.

S10

B: Taylor cannot get changed in front of you. The theatre said that it would be 'inappropriate'. *(Looks down at her semi-naked body and back at the audience.)*

I began to look at the internet because I knew that Taylor was just being allowed to. I typed in the things I thought an inquisitive foal might. I tried to look at everything I found through the eyes of a nine-year-old girl. And when I did that. I started to feel sick.

BRYONY places the microphone on the floor. She slowly begins to change into her armour. Taking her time, commanding the audience to take stock of her adult body and its movements. Firstly she removes her long blonde wig, revealing a shock of bleach blonde hair. Then she fetches her suit of armour laying it out carefully in front of her with great ceremony. Her movements are masculine and every now and then she looks towards the speakers where a slow, foreboding choral drone is building with tension and that same feeling of impending doom from the beginning of the show.

The music builds, it has a dance beat now, a pulsating dark grimy beat that has a bass that you can feel in your chest. Once dressed, BRYONY picks up microphone, pretends it's a baseball bat tapping it into her hand, then a sword crossing her own body with a practice swing. TAYLOR appears from behind the mound, a perfect little knight complete with real silver baseball bat and ear defenders and bleach blonde hair. She walks with steady paces to BRYONY. The pair walk forward DS into powerful light. Noble creatures, hard as fuck. BRYONY stops DSC and TAYLOR continues into the audience, climbing the centre stairs or up into the audience over the chairs. She heads high, lit like a god and slowly hitting the baseball bat into the palm of her hand like someone ready to fight.

BRYONY begin to pace on the spot, agitated and twisting her neck slowly from side to side. Then into the eyes of every single audience member...

B: Today I saw a babe with a chainsaw.

Two women slashing at each other with long fake nails.

A body being slung from a bridge.

A thick handle shotgun being pressed hard into someone's jaw.

A punch so violent it made two teeth go through a lip.

A bloodstained hotel room.

Two bodies tied to a chair with plastic bags on their heads.

A woman shitting into another woman's mouth.

A nine year old kidnapped by fourteen year olds.

Two hard-looking cunts with baseball bats.

A group of women crowding around, kicking another woman on the floor.

Hipbones sticking out over white briefs.

A young thin body hanging from a tree watched by three Dobermans wearing diamante collars.

A man in mirrored shades and a designer suit snorting cocaine off the tits of a woman.

A kid pretending to be a slutty pop star in a shopping centre.

A sexual attack filmed on a Blackberry.

A hate crime filmed on an iPhone.

A rapper throwing dollar bills at the crotch of a young woman.

And a video game character slamming a prostitute's head in the door over and over and over and over and over again.

Shouting now.

Now if I'd of seen it by myself I probably would of let it wash over me like usual. But I didn't, I saw it with her sitting next to me, watching CBBC as I clicked through on the family iPad. And I suddenly felt all the rage in the world coursing through my veins. This is it? This is the legacy I have to pass to her?! I wanted to throw myself under horses for her, I wanted to fire rockets into board rooms... I wanted to stand like Gandalf, on a tiny bridge, in a massive canyon and scream at a huge fire-breathing dragon... YOU SHALL NOT PASS! Not on my fucking watch. And I knew what my sister meant when she said I needed to fight, but I didn't know who and I didn't know how.

The music reaches a deathly crescendo, almost too loud, it's dangerous and fills the space in a huge way.

BRYONY throws the mic backwards towards the mound and she has suddenly lost TAYLOR in a barren wilderness. She looks wildly about for her, screaming her name into the sky. TAYLOR hears and responds, rushing down from her outlook, ripping off her ear defenders. She finds her aunty screaming...

T: I'm here Aunty Bry! I am here!

BRYONY crouches down on one knee, takes hold of TAYLOR's shoulders looks her in the eye and firmly shakes her as she screams...

B: Fight! Fight Taylor...everything everyone. IT'S TIME TO FIGHT!!

S11

The pair fight an invisible army on the stage. Every movement has added headbang in it, hair flings back and forth and makes it like dancing and fighting at the same time. They alternate between smashing things with imaginary baseball bats, firing machine guns into the audience and around the stage, getting bugs out of their hair and roundhouse kicks, it's mental and

manic and hardcore. They change positions, TAYLOR goes to the mound, BRYONY writhes on the floor.

Suddenly BRYONY asks TAYLOR to cover her. She runs to the backpack flinging it open and grabbing a oversized glittering red apple. She runs towards TAYLOR with it, the music goes to a slow motion choral uplift, as if the apple is magic BRYONY thrusts it in the air in slow motion, TAYLOR stretches her entire body as high as it will go in slow motion to take the magic apple from BRYONY. She pulls the stalk out with her teeth and throws it offstage like a grenade. The pair cover their ears and crouch down as they wait for the explosion. As the explosion comes it blasts TAYLOR backwards, slow motion still into the arms of her aunty in a beautiful fall. The music fades to almost nothing. BRYONY holds dead TAYLOR in her arms and looks to the sky. She steps forward laying her little body down at her feet. Then like a computer game she sits up reanimating. BRYONY follows the same movement, they leap into the air, powering up with a new life and they are fighting again, the music is back.

Suddenly at the back of the room they see a sniper, they move backwards, hands up begging not to be shot. Bang they are shot in the heart, Bang in the side, Bang in the womb. They retreat and BRYONY covers TAYLOR who climbs onto her back and hands her a baseball bat.

Suddenly they are travelling a wild wilderness, stuck in imaginary brambles, TAYLOR shouts instructions at her aunty who is lost and chopping down the brambles and fighting to get through. BRYONY flings TAYLOR off and fights off an army with her baseball bat, TAYLOR disappears back behind the canvas. BRYONY has lost TAYLOR again, calling her name, screaming, manic. TAYLOR appears calling her aunty, she is carrying two very heavy old AK-47s, Chinese ones with the wood. They load and lock the guns with excellent accuracy and speed and they fire them, making the noises with their mouths, thrashing their hair and screaming, howling into the night, at the audience. Convulsing like maniacs.

BRYONY catches herself, she hates herself, she stops and she watches TAYLOR manically firing a gun, at an audience, it is crazy, she sees it now. The music is deranged and like being on too many drugs. She places her hand on TAYLOR's shoulder, the music instantly stops, all you can hear is the forest and the birds. TAYLOR stands deathly still, so does BRYONY.

S12

BRYONY moves first, taking TAYLOR by the arm spinning her round into her embrace and daddy walking her slowly to the centre of the mound. BRYONY plops her down with her back to the audience, she holds her face and looks hard at her for a moment. She then heads to her backpack, this time she brings out a shiny silver tray, a piece of dull cloth covering its contents. She stands directly in front of TAYLOR and asks her to hold the tray, she takes up her face in her hands again and studies it.

BRYONY takes a large beautiful silver spoon from the tray in TAYLOR's hands, tilts TAYLOR's head back and takes a breath. In a matter of fact, determined way she removes one of TAYLOR's eyeballs. The sound effects playing are horrifically gory. When the eyeball pops out, BRYONY places the spoon in her mouth and takes hold of it with her hand, she pulls hard, TAYLOR struggles and suddenly above TAYLOR's head the ball can be seen. It has the longest, most glittery, optic nerve attached and it just keeps coming until about a foot from her head it gives and the eyeball is completely removed. The eyeball looks at BRYONY, then at the audience. BRYONY throws it on the floor like it is dirty, it lands with a dull thud. BRYONY blows into the open hole and nods.

BRYONY then removes the other eye, the same rigmarole, the same long glittering ridiculous nerve and the same thud. Once this is done she bandages TAYLOR's face carefully, turns her round to face the audience and the blood slowly seeps through the bandage. BRYONY places the ear defenders back on TAYLOR with rough determination. She also clips TAYLOR back onto the lead. She nods again. Protected.

S13

BRYONY picks up TAYLOR around the waist and carries her over to her little microphone. Bowing down at it…

B: Then just as I realised it was a role model's job to act as a guide to this little idiot I realised the real world had already seeped in…around the edges of the family battlements. She knew everything already. Of course she did. This, ladies and gentlemen is 'The Oracle'.

BRYONY places TAYLOR in front of her mic, placing her little hand on it to steady her. BRYONY goes and lies down in front of the mound, straight, staring at the ceiling.

T: *(Whispering, slowly.)*

I have a brother who is thirteen. He has information.

I have a brother who is fifteen. He has more information.

I have an aunty who is thirty-two. She has information and I know all of it.

I have a mobile phone. That has information.

I have access to more information than you can fit in all the hedgerows in England. Times fifty million.

I consume seven hours of digital information a day.

I am part of a new frontier.

I am The Oracle.

I am the future.

I make the information and I make myself.

You have no idea about power.

You have NO idea about. Power.

She turns slowly to the mound.

Pause.

S14

Aunty Bry?

She drops to her knees and slowly feels her way back to the still body of BRYONY. As she touches her BRYONY speaks, tired and half asleep.

B: OK, I'm awake. I'm awake. What do you want?

TAYLOR climbs onto the belly of BRYONY and curls up into a tight ball.

T: A story please.

Pause.

B: A story?

Pause.

B: *(In a fairy tale voice, over the top of fairy tale twinkling music, sometimes BRYONY strokes TAYLOR's back, sometimes TAYLOR makes little noises of agreement.)* There once was a dinosaur who thought she had to fight the world. She would run through the forest at a mighty speed. Smashing down trees, screaming from cliff edges, getting angry and loud if things stood in her way. Usual dinosaur stuff. One day she was resting in a clearing and it was very quiet. Her bones ached. She was thinking about the cuts and bruises on her body, she was thinking about the eggs she had forgotten to lay, she was wondering about why she was alive at all. Existential dinosaur matters. And who should appear but a tiny baby deer, a fawn. Its tiny little feet scuffing the leaves and its little nose carefully sniffing the grass. She watched quietly and found quite by chance that she was made happy by its movements, its little trembling stick legs, its big wondrous eyes, its nervous discovery. She wondered if it ever spent its time raging against the darkness in the forest and concluded…probably not. When the dinosaur

moved the fawn was at first petrified, but she spoke at it with soothing coos and encouraged it to clamber onto her back. So small. She asked the fawn to tell her what she wanted for the world. The fawn explained that she wanted happiness and she wanted safety. The dinosaur had only ever wanted to stop things, never to create or encourage things. She began to think about what she wanted, rather than what she didn't want for the world. And the dinosaur and the fawn became great friends.

Pause.

BRYONY turns her head to the audience.

S15

B: In the sixties, a group of psychologists from Stamford University in America began a study. They decided to ask one hundred nine year olds to put in order of preference a list of personality traits they hoped to possess as adults. They decided to conduct this study every decade to see how children changed over time. For the first forty years the top aspirational personality trait was 'kindness'. Until 2010, a nine year old's biggest hope was that they could be kind when they grew up. Then with that year's study, perhaps because of a decade of hyper celebrity culture, perhaps because of Hannah Montana, perhaps because of a change in the wind...kindness went down to fourteenth place and it was replaced at the top spot by 'famous'.

At first this was just another thing to get mad about, but then I realized we could do something with this information. That I could do something to become a good role model for Taylor... I could somehow use the mechanics of fame to offer an alternative to the stuff that had made me so angry. I could try to infiltrate the industry and flip it on its head, David and Goliath style. Use the appeal of popular culture to offer a different and new message... Taylor?

Pause.

TAYLOR sits up.

T: Yes.

B: Shall we stop pretending your eyes have been gouged out now?

T: Yes.

B: Why don't you tell these lovely people what we have been working on for the past year or so.

T: OK.

They both stand readying themselves. The lights change, the fairy tale shine comes off. TAYLOR takes off her chain mail. BRYONY unzips her boots for her. BRYONY fetches TAYLOR's speech cards and stands in a lunge position holding the cue cards and TAYLOR's mic at the height she thinks TAYLOR stands at. TAYLOR comes over and thanks BRYONY. She talks out the audience from her cue cards, taking her time. Underneath her speaking is an instrumental broken down version of Catherine Bennett's song 'Apathy' to keep the pace. BRYONY tidies the stage a little. She moves her mic stand to centre, sets the backpack and ear defenders beside it.

S16

T: About a year ago me and my aunty Bryony began to look at the role models that were offered to kids like me on TV, in music and online. We found they were all very similar. Lots of them talked about fame and money, the girls all wore sexy clothes, the way they made you feel was the same, most also tried to sell you something. She asked me if I would like to create our own role model, one made by me for kids my age. I said yeah I thought it sounded fun.

BRYONY and TAYLOR shake hands.

I chose my top five personality traits for a role model from a list that Bryony gave me. These were:

Kindness
Community
Tradition
Hard Work
And
Safety

I then created a character that had these traits. Bryony asked me hundreds of questions all the time. I was in charge. I became the manager. She would then goes away and make these things come to life. It was very fun. And a bit strange.

BRYONY has brought on the silver metal table and set it just behind TAYLOR with the shorter end against her back. She picks up TAYLOR and places her seated on the table and goes behind the curtain.

I created Catherine Bennett.
She works in a museum with the dinosaurs.
She has a dog called Cookie.
She is twenty-nine.
She is good at what she does. She worked hard to get there.
Her favourite food is Tuna Pasta.
Her bedroom is light blue.
She goes to the gym everyday and practices martial arts.
She has a boyfriend called Matthew and a best friend called Chelsea.
Matthew is a proofreader.
Chelsea is a midwife.
To relax she reads.
Her favourite film is *War Horse.*
She likes 80s music.
She cycles everywhere.
Her favourite TV programme is *Come Dine With Me.*

Catherine has shoulder length blonde curly hair
She wears glasses and a dinosaur bone necklace to

remind her of her job at the museum.
She wears blue eyeshadow and red lipstick for fun.
She wears knee length skirts and likes polo necks.
She is quite clumsy so doesn't wear high heels. She
always has a backpack. She is a normal lady.

I decided that pop music was the best way to reach
people my age. Because it is what most of the kids at
my school watch on YouTube. So CB became a pop
star. So she could spread her message with the world.
Be an alternative pop star role model. I thought CB
should sing about things that me and my friends like.
Animals, funny-shaped vegetables, friendship, getting
out of bed and what life is like in the future.

Catherine Bennett wants people to believe that
anything is possible in life. She wants everyone to use
their imagination. And she wants to make sure no one
ever feels small. She is silly so that other people know
it's OK to be silly too.

In her best introduction voice, nice and loud.

Ladies and Gentlemen introducing our creation.
Catherine Bennett.

S17

*A big drum roll and intro music plays and from behind the curtain
bounds CATHERINE BENNETT, all smiles and curls and she is
waving, at the audience and at TAYLOR. As she arrives at her
mic the music stops. House lights come up.*

B: Oh hello kids! Thanks for letting me come into your
 assembly. I am Catherine Bennett, palaeontologist and pop
 star, this is Taylor my nine-year-old manager. We are here
 today to talk to you about role models, where to find them
 in your community, in stories or on TV. We are going to
 listen to music, talk about history and about the body but
 first I heard that you do dance? I heard you are very good!
 So I wanted to teach you a dance that Taylor and I made

up with the help of our friends Figs in Wigs. It's a dance for my song 'Animal Kingdom', a tune about animals and friendship and how we can learn a lot from nature. So have a little stretch and get ready. Here we go.

The music underneath fades away. The audience join in. TAYLOR does the same moves as CATHERINE BENNETT.

First up we have a crab and a crab *(Right hand crab hand forward, left hand crab hand forward.)*

Great well done!

Crab…crab. *(She does it again demonstrating, the audience follow.)*

Deer… Deer. *(She places her right then her left hand on top of her head like ears.)*

Great.

Now we have a move you might not know as it's quite old fashioned, it's a hand jive. *(She does it.)* So hand jive fish. *(She slaps her hands on top of each other to make the shape of a fish.)* Swim him to the side. *(This line is in a funny deep voice, she swims the fish to face the right.)* Hand jive fish, swim him to the side. *(She repeats.)*

Then we have a rather stampy horse. Clip clopping along. 1, 2, 3, 4. *(She turns her hands into stamping horses legs.)*

Oh Taylor is doing the professional version, where on the 3 and 4 you can make the sound of a horse. *(She blows air through her lips to make a horse sound).*

Again 1, 2, 3, 4. Good! Professionals too!

OK now we have on our hands a really rather shy duck. That's right. *(She places her right arm at a right angle and clasps her hand like a duck's face. Her left hand holds her elbow.)*

She will only look at you when you are looking away. *(She makes the duck face look at her while she looking to the left.)*

When you look at her she looks away. *(The hand turns away as CATHERINE BENNETT turns her head right to look at the duck face.)*

When she looks back, you look away but more as a sign of respect. *(Hand looks, CATHERINE BENNETT looks away.)*

Then you snaffle a kiss. *(She kisses the duck face hand with a loud smack.)*

TAYLOR and CATHERINE BENNETT laugh at the duck.

Monkey monkey. *(She lifts her right arm and scratches her arm pit.)*

Jump jump. *(Jumps on the spot.)*

Snake goes under a log. *(Right arm under left.)*

Has a lie down. *(Opens arms out straight to the sides.)*

Cross your heart. *(Cross arms across chest.)*

Hope to die. *(Hands on shoulders.)*

Two giraffes. *(Arms above the head hands point right then left.)*

And a bird. *(Arms flap back down outstretched to the sides.)*

CATHERINE BENNETT and TAYLOR laugh again. It is fun.

B: OK so now we are going to try and do it all together. Let's try a slow version please.

She calls out the names as the slow version plays. They do it once through.

Crab crab, deer deer, hand jive fish, swim it to the side, horse horse, *(Noise of the horse.)* shy little duck,

kiss, monkey monkey, jump jump, snake goes under a log, has a lie down, cross your heart, hope to die, two giraffes and a bird!

Great! That was amazing. Now I think you are ready for the real version. Brace yourselves, its quite fast.

They do the fast version through twice, it's manic and hilarious. CATHERINE BENNETT sings the song like a pop gig. Afterwards she encourages them to give themselves a round of applause. CATHERINE BENNETT and TAYLOR are happy.

House lights down. Pause. CATHERINE BENNETT snaps back to Aunty Bry.

S18

Is that what she is like?

T: Yes.

Can you sing me another one of CB's songs Aunty Bry… please?

B: *(Pulling a face.)* OK, but only if you promise you will go to sleep.

T: OK.

BRYONY lays TAYLOR down on the little silver table. She pivots it to be side on of the audience, dead centre. She places the ear defenders on TAYLOR's stomach. She takes great care to make sure her feet and head are exactly at the edges of the table. She closes TAYLOR's eyes with her fingers and places a finger on her mouth.

BRYONY goes SR with her mic stand. The lights go hazy, like a nightclub, CB's green dress sets off the light like a nightclub singer, TAYLOR sleeps.

BRYONY sings a slow lullaby version of the Catherine Bennett song, 'Apathy'. It's sweet and slow.

B: *It's a mystery to me why I'm so slow*
Nothing motivates me
Where's my get up and go

I've tried so hard and so long
Just to m-m-motivate and get the job done
I've tried so long and so hard
Now I'm back at the start

I'm tiptoeing tightropes
I'm taking too long
I'm breaking and I'm shaking
Scared to get the job done

I'm slipping into shadows
I'm sliding under rocks
I'm dripping with excuses
I'm hiding all the clocks

She trails off, knowing TAYLOR is fast asleep.

S19

To the audience.

B: This is still happening as we speak and Catherine Bennett is doing alright, out in the real world, for adults. She has tens of thousands of hits on YouTube, she has been played on Radio 1, she has been on *Woman's Hour* with Taylor, she was invited to speak on the activism stage by Yoko Ono for the Meltdown festival, she has even been to parliament with Taylor to talk about why we felt we needed to create a new role model for kids Taylor's age. People are responding really beautifully to our call to arms.

But I stupidly promised Taylor some pretty massive things when we began this project, I got overly excited. I promised her the things that she saw as clear indicators of fame. One million hits on YouTube, an invite to LA to be on the Ellen Show, to get more famous than Jessie J. So we are a bit of a long way off!

The difficulty with this project is that the power for change lies in the hands of Tweens, the hardest to reach market of all. Jessie J's PR and marketing budget for next year is just over six million pounds. We have £2.50. Tweens are used to and expect an extremely sophisticated and large scale marketing campaign to sell them anything, they are bombarded with so much information it is hard to make a mark. It is not our intention to tell kids why Katy Perry or Jessie J may present a really rather limited version of race, power and sexuality, what would that achieve? We also don't want to explain to them why sex sells...or how and why they are being manipulated. The intention has always been just to put a different message out there, an alternative. In the hope that more alternatives crop up and culture shifts slightly in a new and more positive and diverse direction.

So to reach that group the best way is to visit them in their natural habitat...schools. So every day of summer term and now this term I have visited a different school assembly. 200 kids, with ears ready to listen and learn are exposed to Catherine Bennett and her wonky, weird and wonderful world and it works! Even the hardest of kids melt when asked what music could be about if it wasn't money, fame or love. The best suggestions so far have been Air Hockey, Pizza and Water Parks.

I was in Peckham the other day after one such assembly, back in my real life clothes and in the playground I asked a little girl what she wanted to be when she grew up. She said 'Oh I used to want to be a pop star, but now I quite like the idea of digging up bones like Catherine Bennett does'!!

My womb nearly exploded! I was so happy.

So I have realised we can only take it one step at a time, this little nine year old communicates to other

people her age, using her aunty as a conduit, bypassing the sales teams and boardrooms and providing imaginative, gender neutral, empowering popular culture as an antidote to the crap role models we found out there. And if only a handful of kids change the way their feel about themselves or what they aspire to be then of course we are still winning.

S20

But what about us two? What about our little journey of discovery together?

Let's talk openly shall we?

She removes CB's glasses and wig, she takes the mic back to the table where TAYLOR sleeps. She places the ear defenders on TAYLOR. She takes a breath. Standing behind the table like a dissection or demonstration is about to take place. She looks the audience right in the eye. This is slow.

B: So, I, Bryony Kimmings, make very self-referential, autobiographical, some might say *(She puts her hand over the mic to hide her mouth.)* self-indulgent… Performance Art work. *(She does a spin and places her hands in the air and gives the audience a huge smile.)*

Pause.

And I always thought that my story was more important than everyone else's. So this project knocked me for six because suddenly someone else's story suddenly became more important than mine. *(She touches TAYLOR's legs in front of her.)*

She made me want to be a better citizen of the world.

Now the parents among you will bow your heads knowingly and laugh a little and say to me 'Bry! The real test of selflessness, strength and nerve will come when you push out your own love!' and I hope I will.

She gestures to the size of TAYLOR.

Smaller than this. Less hair.

But I no longer think that is true. I am not sure that just parents looking out for kids is good enough anymore.

Because having delved deep into their world, looked it in the eye, run away scared, tried to battle it and then tried to take it on at its own game I have realised that the world is just a very dark place for these lot. It is very different to how it was in our day.

So I don't think that is enough, do you? I know *I* stand here, faced with the hideous complications of somehow being responsible for the next generation. Ready to pass on a blackened greasy baton to them with a feeling of guilt, anger and the desperate need for redemption. Clawing at some modicum of false hope that someone else will set this all straight somehow.

I set out to find a good role model for this little person. *(Touches TAYLOR.)* And I don't know if Bryony Kimmings is a good one for her, or if the maniac that is Catherine Bennett will serve her well, but that is what she asked for, so that is what she has been given, she obviously felt she needed this kind of role model at this time.

Now… I know more than anyone right now that Taylor won't always be able to be in this show as she has been tonight. She is nine. She is literally 'between'. She is right on the cusp, I can feel it. She is about to make that journey from Fawn to Dinosaur that we all had to make. Her body won't always fit so perfectly on this little table. Her hips will grow, she will grow shy and she will probably forget all about this summer with her Aunty Bry.

So I wanted to send Taylor to sleep at the end of this show. So I could somehow symbolically wake her up anew. I wanted to send her away at the end, with some

of the things that she might need for the journey ahead of her. Perhaps things I wish I had had. Some feminist awareness (they don't teach that at school), a sense that her voice is valued and that she has the power to change the world if she wants to, and some bloody good memories. So I will wake her, not with a kiss from a prince, as that is shit! Not even with the promise of happy ever after, because I can't do that to her. But I will wake her instead, with the hope that we will ALL make the world a better place for her to exist in.

She wakes TAYLOR by gently poking her little nose. TAYLOR sits up.

B: Morning.

T: Morning.

B: It's nearly time to go.

T: OK.

BRYONY goes and picks up the backpack.

B: I got you a present. *(To the audience.)* This is an excellent example of pester power.

She pulls out of the bag a long green princess dress for TAYLOR. TAYLOR is very happy. BRYONY does a fake gag as she displays it. TAYLOR begins to put it on.

I took the liberty of getting one for myself.

BRYONY runs fast to behind the screen, it is funny, like a kid. TAYLOR struggles to put the dress on.

From behind the screen.

You OK?

T: Yeah! *(Struggling.)*

B: I thought perhaps we could do that dance one more time, the one from the beginning? The one we made up in your bedroom. Is that OK?

T: Yeah!

S21

BRYONY comes back round wearing the long navy princess dress, the same as TAYLOR's.

They are both stupidly long and the pair bumble around the stage for a moment clearing space to dance. They ready themselves in the same way as at the beginning, gazing out like regal princesses. 'Domino' plays. They begin to repeat the routine from S1 but quickly BRYONY becomes more focussed on watching TAYLOR doing the dance, like a proud but sad aunty. It's a gaze that is both encouraging and defeated. TAYLOR dances perfectly, like a nine year old, having fun. When there is a moment they face one another, BRYONY does it to ensure TAYLOR doesn't feel self conscious at her staring. At the end as they come together instead of doing a spin BRYONY grabs hold of TAYLOR and picks her off the ground covering her with kisses and dragging her forward to DSC. The music fades out. BRYONY takes the backpack and places it slowly onto TAYLOR's back. She bends down behind her and says into her ear whilst pointing, arm outstretched, to the theatre exit.

B: So it's out that door, down the stairs and out into the real world.

T: OK. Bye, love you *(She kisses BRYONY on the cheek.)*

She sets off and as she reaches the exit. BRYONY calls after her.

B: Taylor!

TAYLOR stops.

Don't forget I will be right here on this stage if you need me.

T: OK Aunty Bry. Bye.

B: Be careful.

BRYONY watches her exit, slowly turns to face the audience and looks for a few moments. Usually by this point she is crying.

Lights fade to black.

WWW.OBERONBOOKS.COM

 Follow us on www.twitter.com/@oberonbooks
& www.facebook.com/oberonbook